To
Marie
Enjoy !
love
Wendy &
John

Published simultaneously in 1994 by Exley Giftbooks in the USA and
Exley Publications in Great Britain.
Copyright © Helen Exley 1994, Editor
ISBN 1-85015-525-9
Picture research by Image Select. Typeset by Delta, Watford.
Printed and bound by Grafo SA, Bilbao.
Exley Publications Ltd, 16 Chalk Hill, Watford, Herts WD1 4BN, U.K.
Exley Giftbooks, 232 Madison Avenue, Suite 1206, NY 10016, USA.

Exley Publications gratefully acknowledges permission to reproduce copyright material. Whilst
every effort has been made to trace copyright holders and acknowledge sources and artists, the
publishers would be pleased to hear from any not here acknowledged.

ROY BOLITHO: extract from an article in *Reader's Digest*, September 1982; WINSTON
CHURCHILL: extract from *My Early Life*, published by Harper Collins, reprinted by permission of
Curtis Brown Group Ltd.; LEO AND JILLY COOPER: extract from *Horse Mania*, published by
Bell & Hyman, 1986, a division of Harper Collins © Leo Cooper 1986; FRANK CREW: extracts
from *Devoted To Horses*, published by Frederick Muller, 1955, Hutchinson and Random Century
UK; JACKIE CROOME: extract from *The English And Their Horses*, published by Bodley Head
and Random Century UK; WALTER DE LA MARE: extract from *Nicholas Nye*, reprinted by
permission of the Literary Trustees of Walter de la Mare and The Society Of Authors as their
representative; MONICA DICKENS: extracts from *Talking Of Horses*, published by William
Heinemann Ltd., 1973 and Reed International Books.; J. FRANK DOBIE: extract from *The
Mustang – Wild And Free*, reproduced in *The Horseman's Companion*; DAME MARY GILMORE:
extract from *The Wild Horses*, published by Angus & Robertson and Harper Collins, © The Estate
Of Dame Mary Gilmore; JAMES HERRIOT: extract from *It Shouldn't Happen To A Vet*, published
by Michael Joseph Ltd. and St. Martins Press Inc. and Penguin Books © James Herriot 1970,
1972, 1973; FERENC JUHASZ: extract from *Birth Of The Foal*, from *Poems For Spring*, published
by Wayland (Publishers) Ltd., 1990; MARY KENNEDY: extract from *The New Born Colt*,
reproduced in *A Classic Illustrated Treasury/Horses*, published by Chronicle Books © 1992 The
Blue Lantern Studio; BERTRAND LECLAIR: extracts from *1001 Images Of Horses*, published by
Tiger Books International © Colour Library Books Publishing and Copyright SARL, Paris, 1992;
HRH THE PRINCESS ROYAL: extract from *Riding Through My Life*, published by Pelham Books
and Penguin, 1991; VERNON SCANNELL: extract from *The Horse* from *Travelling Light*,
published by Bodley Head and Random Century, 1991; STELLA A. WALKER: extract from *In
Praise Of Horses*, published by Frederick Muller, 1953, Hutchinson and Random Century UK;
LOUIS WATCHMAN: extract from *War God's Horse Song*, published in *The Rattle Bag*, published
by Faber & Faber Ltd. 1982; BARBARA WOODHOUSE: extracts from *Talking To Animals*,
published by Allen Lane The Penguin Press 1980, and Penguin Books.
Picture Credits: Exley Publications is very grateful to the following individuals and
organizations for permission to reproduce their pictures: Archiv Für Kunst (AKG), Art Resource
(AR), The Bridgeman Art Library (BAL), Edimedia (EDM) and Fine Art Photographic Library
(FAP). Cover: Julius Paul Junghans,(BAL); title page: 14th century book illustration (AKG); pages
6/7: Edgar Degas, (BAL); page 8: Oskar Merte, (BAL); page 10: Wassili Werestschagin, (AKG);
page 12: 16th century Iranian miniature (EDM); pages 14/15: Remington von Frederic, (AKG);
page 17: Basil Bradley, (FAP); page 18: Harold Harvey, (BAL); page 21: John Frederick Herring,
(FAP); page 23: Franz Marc, © Erich Lessing (AR); page 25: Harry Fiddler, (FAP); pages 26/27:
Julius Paul Junghans, (AKG); page 29: Lady E. Southerden Thompson Butler, (BAL); pages 30/31:
Joseph Denovan Adam, (BAL); page 33: © 1994 Lucy Elizabeth Kemp Welch, (EDM); pages 35 and
60: © 1994 Sir Alfred Munnings, (FAP); page 37: Michael Therkildsen, (FAP); page 39: © 1994 Sir
Alfred Munnings, (FAP); page 40: Dorothy Adamson, (BAL); page 42: George Stubbs, (BAL); page
45: Paul Gauguin (AKG); page 47: R.H. Brock, (FAP); pages 48/49: Franz Marc, (BAL); page 50:
Edgar Degas, (EDM); page 53: Robert Polhill Bevan (BAL); page 54: Henri de Toulouse-Lautrec,
(BAL); page 57: © 1994 Ruth Gibbons, (BAL); page 58: Wilhelm Leibl, (AKG).

\mathscr{H}ORSES

A CELEBRATION
IN WORDS
AND PAINTINGS

SELECTED BY
HELEN EXLEY

EXLEY
NEW YORK • WATFORD, UK

... galloping where you know the ground is open and safe, racing with other horses – ah, there is nothing like it this side of Paradise, or even the other side, unless we do get wings.

MONICA DICKENS (1915-1992)

Who has not dreamt of some mad race along a deserted beach, the wind and spray in your face, as you gallop in wild abandonment?

BERTRAND LECLAIR

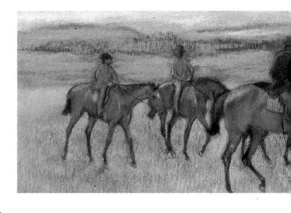

When Allah created the horse, he said to the wind, "I will that a creature proceed from thee. Condense thyself." And the wind condensed itself, and the result was the horse.

MARGUERITE HENRY,
FROM *"KING OF THE WIND"*

In riding a horse, we borrow freedom.

PAM BROWN, b.1928

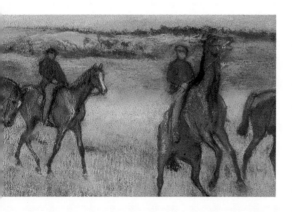

Listen to the epithets with which spectators will describe the type of horse: the noble animal! and what willingness to work, what paces, what a spirit, and what mettle; how proudly he bears himself – a joy at once, and yet a terror to behold.

XENOPHON (435-354 B.C.)

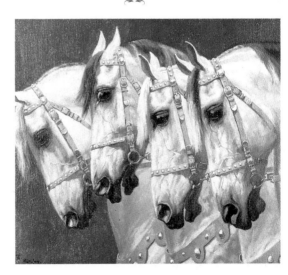

I will not change my horse with any that
 treads....
When I bestride him, I soar, I am a hawk.
He trots the air; the earth sings when he
 touches it.
The basest horn of his hoof is more musical
Than the pipe of Hermes....
He's the colour of nutmeg and of the heat
 of the ginger...
He is pure air and fire, and the dull elements
of earth and water never appear in him
But only in patient stillness while his rider
 mounts him...
It is the prince of palfreys. His neigh is like
The bidding of a monarch, and his countenance
Enforces homage.

WILLIAM SHAKESPEARE (1564-1616)

What a piece of work is a horse!... The beauty
of the world! The paragon of animals!

JAMES AGATE (1877-1947)

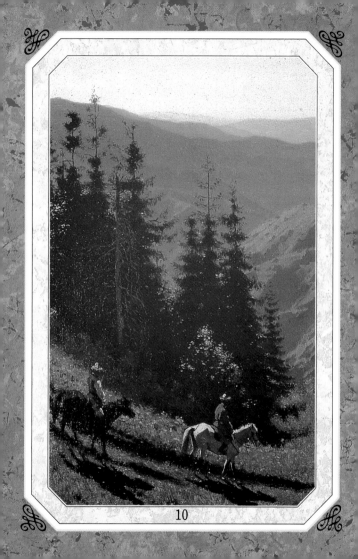

FREEDOM

Pony or horse trekking give the word freedom its true meaning – as you sit up above the world in a silence that permeates from the tip of your riding boot to the top of your hard hat.

BERTRAND LECLAIR,
FROM *"1001 IMAGES OF HORSES"*

Then we began to ride. My soul smoothed itself out, a long-cramped scroll freshening and fluttering in the wind....

ROBERT BROWNING (1812-1889)

The symbol of wide open spaces and freedom, synonymous with nature in a mechanised world, the horse arouses great passion and feeds our imaginations.

BERTRAND LECLAIR

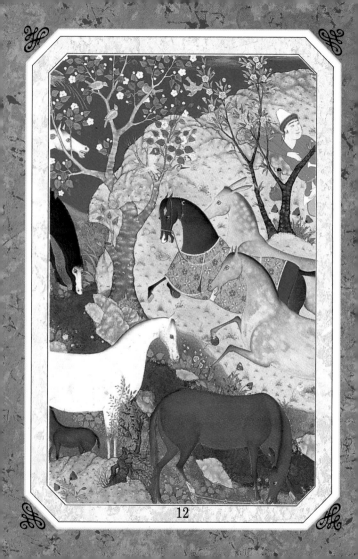

PARADISE ON EARTH

...I found that a German had expressed it all in one simple sentence: "On the back of a horse you will find Paradise on earth."

Subsequently I discovered that for thousands of years men and women of all nations had been singing a song of praise about the horse. Even as far back as 1360 B.C. the Hittites were inscribing clay tablets with their horse lore. The Greek philosophers wrote of the speed of their chariot racers. The Conquistadores recorded the outstanding qualities of their battle chargers.

Poets have eulogized their palfreys, and kings and queens acclaimed their hunters. In every diary of the past, some famous and some obscure, many pages are devoted to the virtues of horses....

STELLA A. WALKER,
FROM *THE FOREWORD TO "IN PRAISE OF HORSES"*

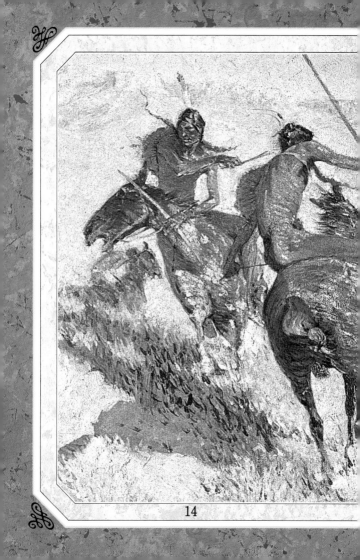

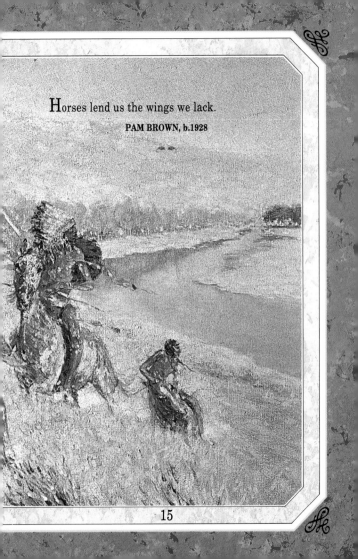

Horses lend us the wings we lack.

PAM BROWN, b.1928

THE BEAUTY OF HORSES

I am still under the impression there
is nothing alive quite so beautiful as a
thoroughbred horse.

JOHN GALSWORTHY (1867-1933)

... the horse, throughout the history of art,
has been a subject which has inspired some
of the greatest painters – not for its carrying
alone of illustrious people, nor only for its
magnificence and poignancy on the battlefield,
but for its simple grace and beauty,
whether that is reflected by the horse's
place in a country scene, or, more particularly,
in the beauty of a mare's mothering
of her foal.

FRANK CREW,
FROM *"DEVOTED TO HORSES"*

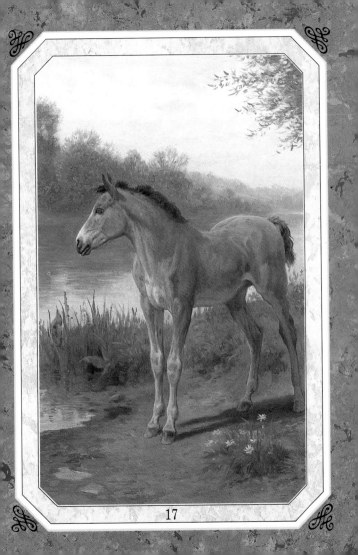

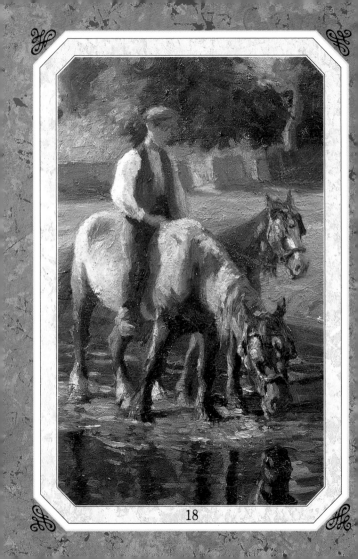

A PARTNERSHIP

You and your horse. His strength and beauty.
Your knowledge and patience and determination.
And understanding. And love. That's what fuses
the two of you into this marvellous partnership
that makes you wonder, what can Heaven offer
any better than what you have here on earth?

MONICA DICKENS, (1915-1922)

...what could be more wonderful than sharing
the daily life of the noblest of domestic animals?
Whether you have a thoroughbred ex-racehorse,
an old school horse saved from being put down,
a palomino – its coat flaming in the sunset – or
a speedy, rough little pony, always ready to go
off on a ride (sometimes the fun starts when you
try to catch it!), horses bring so much happiness
to their owner that the work entailed in keeping
it is soon forgotten.

BERTRAND LECLAIR

OUR BEST FRIEND

Although dogs are always referred to as a man's best friend, it could be argued that the horse has been a better friend to mankind than the dog. Certainly it has been a more useful friend – rivalled in this only by such other invaluables as the wheel, the combustion engine and the Magimix.

From the day Neanderthal man first caught sight of one of the early breeds of horse, he knew he had found a useful ally. This must in fact have taken some imagination, as the early breeds of horse did not at first sight look all that promising. They resembled, to be honest, the rhinoceros, but with thinner legs and without the horn. Not the sort of creature Neanderthal man could have readily foreseen making him a fortune by winning the St Leger. However, you can get a long way with an animal if you begin your training programme in prehistory. So that is what Neanderthal man did.

First there was the question of transport. Long before the Porsche 911 turbo took on the status that it has since acquired, the prehistoric horse was considered pretty stylish. From nought to gallop in two seconds, an open-

topped roadster with real leather upholstery, four-legged drive, and an ability to negotiate extremely rough terrain with an ease and speed which even the Range Rover has never equalled. Very good on consumption too – remarkable mileage to the bale.

LEO AND JILLY COOPER, *FROM "HORSE MANIA"*

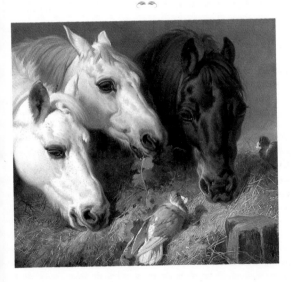

THE MUSTANG – WILD AND FREE

The aesthetic value of the mustang topped all other values. The sight of wild horses streaming across the prairies made even the most hardened of professional mustangers regret putting an end to their liberty.

The mustang was essentially a prairie animal, like the antelope, and like it would not go into a wooded bottom or a canyon except for water and shelter.

Under the pursuit of man he took to the brush and to the roughest mountains, adapting himself like the coyote, but his nature was for prairies – the place for free running, free playing, free tossing of head and mane, free vision. He relied upon motion, not covert, for the maintenance of liberty.

J. FRANK DOBIE

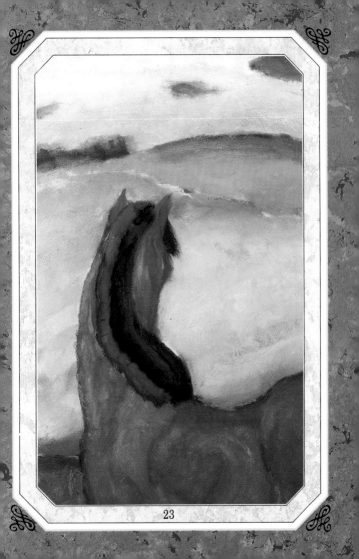

DOWN THE CENTURIES

Perhaps there is still a beauty about turned-up earth and ploughmen working like weavers, designing delicate patterns in brown and green – colours symbolic of agriculture. But tractors in no way stir the imagination like the horses – tireless, indomitable, great hearts driving great muscles, ploughing forward through the days and the weeks and the months, while the sweat of their work salted the earth of the years.

ROY BOLITHO

Gentle, vegetarian, Intelligent and brave,
The horse for countless centuries
 Has been Man's friend and slave.

And next to footprints on the trail
 From Man's dark hidden source
Towards the civilized, we find
 The hoofprints of the horse.

VERNON SCANNELL, b.1922, FROM *"THE HORSE"*

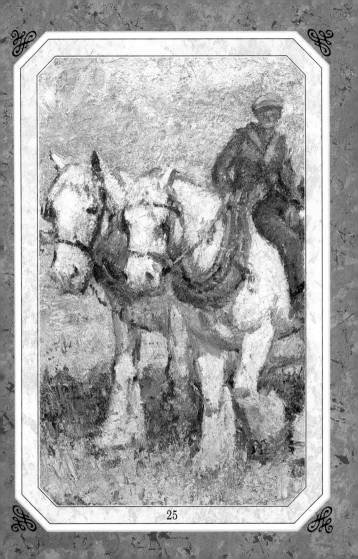

Without the horse what would have become of man? It has served us for transport, in agriculture, industry and every kind of activity since the dawn of time.

BERTRAND LECLAIR

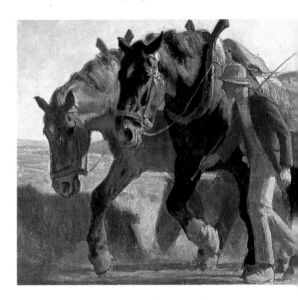

Many persons have sighed for the "good old days" and regretted the "passing of the horse," but today, when only those who like horses own them, is a far better time for horses.

C.W. ANDERSON

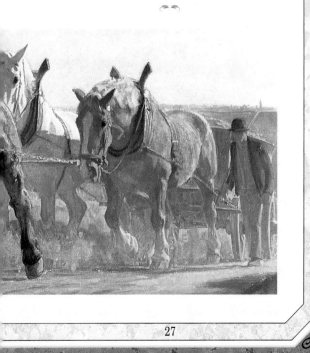

HORSES ABOARD

Horses in horsecloths stand in a row
On board the huge ship that at last lets go:
Whither are they sailing? They do not know,
Nor what for, nor how. –
They are horses of war,
And are going to where there is fighting afar;
But they gaze through their eye-holes unwitting
 they are,
And that in some wilderness, gaunt and ghast,
Their bones will bleach ere a year has passed,
And the item be as "war-waste" classed. –
And when the band booms, and the folk say
 "Goodbye!"
And the shore slides astern, they appear
 wrenched awry.
From the scheme Nature planned for them –
 wondering why.

THOMAS HARDY (1840-1928)

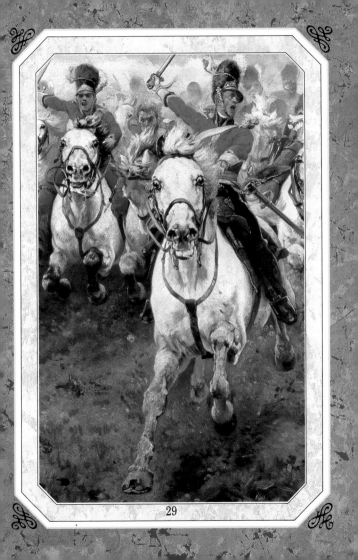

Thousands of years ago, when horses ran free in the wild, they might be killed by beasts of prey or abandoned by the herd when they were old and sick, but they did not suffer from man. We have taken horses from a life in which they could fend for themselves and made them completely dependent on us.

We confine them behind a fence or a bolted door. We feed and water them. We are their source of life.

And so we have a tremendous obligation to

them. A horse must come first. If you don't believe that, if you are not prepared to feed and take care of him before you do anything for yourself, then you shouldn't have a horse.

You probably wouldn't want one anyway. The people who want horses, the horse maniacs, enjoy the stable work as much as the actual riding.

MONICA DICKENS (1915-1922),
FROM *"TALKING OF HORSES..."*

Seem to be smiling at me, he would,
 From his bush, in the corner, of may, –
Bony and ownerless, widowed and worn,
 Knobble-kneed, lonely and grey;
And over the grass would seem to pass
 'Neath the deep dark blue of the sky,
Something much better than words between me
 And Nicholas Nye.

WALTER DE LA MARE (1873-1956), FROM *"NICHOLAS NYE"*

... animals go by, the spirit of their owner.... If
one has a bond with animals they want to join
in one's life as much as they can, and they learn
to pick up one's moods. Tommy knew all mine, I
know. I have laughed with him, rejoiced with
him over successes I have had, and I have cried
into his mane over some unhappiness that only
he would understand. There are so many things
we can tell our animals that we cannot confide
to human beings for fear of being sneered at or
simply not believed.

BARBARA WOODHOUSE, FROM *"TALKING TO ANIMALS"*

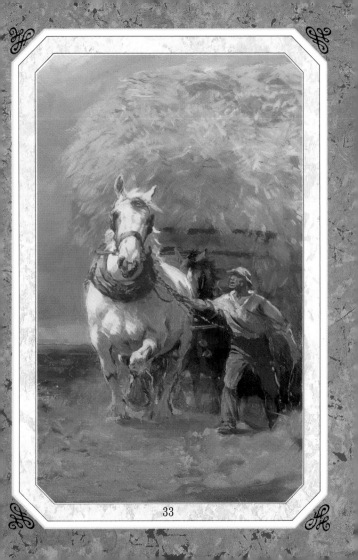

ALMOST HUMAN

I was lying, bolstered up in bed, reading, when I heard the rush of flying feet, and in an instant, with a loud, joyful neigh, she checked herself in front of my window. And when the nurse lifted the sash, the beautiful creature thrust her head through the aperture, and rubbed her nose against my shoulder like a dog. I am not ashamed to say that I put both my arms around her neck, and, burying my face in her silken mane, kissed her again and again.

Wounded, weak, and away from home, with only strangers to wait upon me, and scant service at that, the affection of this lovely creature for me, so tender and touching, seemed almost human, and my heart went out to her beyond any power of expression, as to the only being, of all the thousands around me, who thought of me and loved me.

W.H.H. MURRAY,
FROM *"A RIDE WITH A MAD HORSE IN A FREIGHT CAR"*

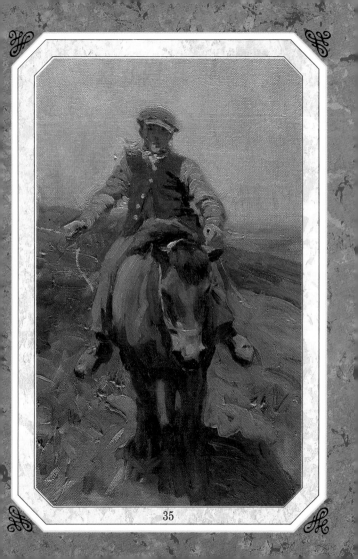

When I had gone to look at this neighbouring *estancia* and the wild horses had been driven in for me, I had found that I couldn't take my eyes off the glorious grey with the proudly arched neck and the long flowing mane and tail. She had snorted as she wheeled madly around the corral at the approach of any human being. I had pointed her out to the foreman, and he had said I couldn't have her, for she'd kill me. I didn't think she would, and directly I saw her I knew she was mine. I loved her wild spirit.... I had got my own way in the end, and the little grey mare had become mine. She had been more terrified than any horse I had ever come in contact with.

When we first met I stood quite still within about four yards of her, and very gently blew down my nostrils. She advanced and raised her beautiful nose to mine, and her sweet-smelling breath reached my nostrils. At once we belonged to each other for eternity.

**BARBARA WOODHOUSE (1910-1988),
FROM** *"TALKING TO ANIMALS"*

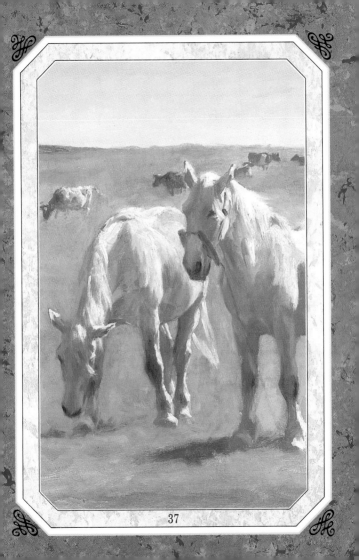

KEEPING YOUR OWN HORSE

Come to the stable. Come to where the horses are, and the sweet grainy, pungent smells.

A horse has the headiest, most satisfying scent of all animals. Mostly because of what he eats. But cows eat grass and hay and clover too, and there is less pleasure in their smell. A cow's breath smells of overfed babies. A horse's breath is a mixture of warm apples and chicken soup.

Everything to do with horses, their food, tack, bedding, smells very good. Everything feels good, the leather, a silky handful of oats, the cool metal of a bit, the smooth licked edge of the manger.

MONICA DICKENS, FROM *"TALKING OF HORSES..."*

Closeness, friendship, affection: keeping your own horse means all these things.

BERTRAND LECLAIR

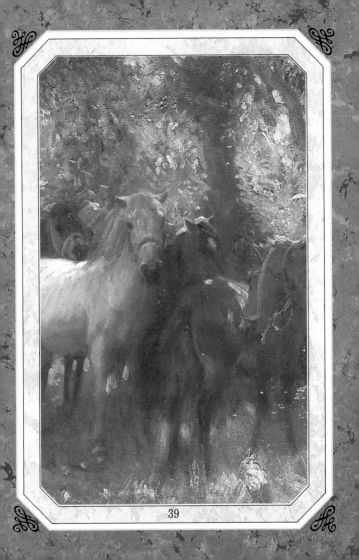

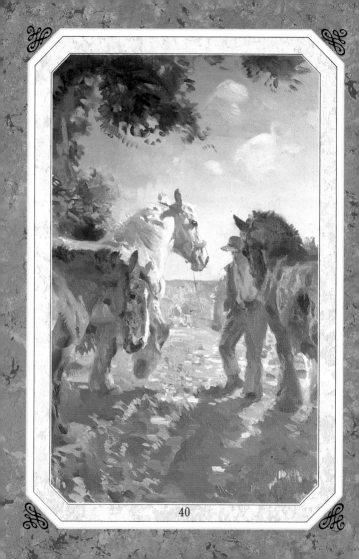

"When did they last do any work?" I asked.

"Oh, about twelve years ago, I reckon."

I stared at John. "Twelve years! And have they been down here all that time?"

"Aye, just lakin' about down here, retired like. They've earned it an' all." For a few moments he stood silent, shoulders hunched, hands deep in the pockets of his coat, then he spoke quietly as if to himself. "They were two slaves when I was a slave." He turned and looked at me and for a revealing moment I read in the pale blue eyes something of the agony and struggle he had shared with the animals....

Yet what made him trail down that hillside every day in all weathers? Why had he filled the last years of those two old horses with peace and beauty? Why had he given them a final ease and comfort which he had withheld from himself?

It could only be love.

JAMES HERRIOT,
FROM *"IT SHOULDN'T HAPPEN TO A VET"*

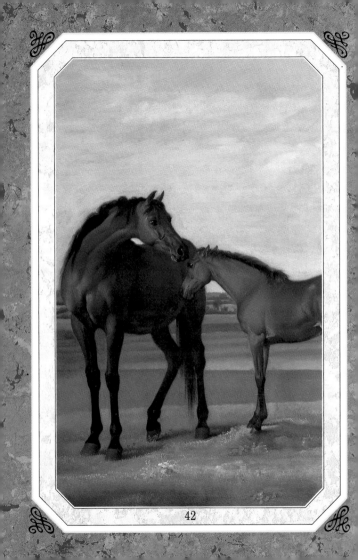

FOAL!

It dances –
The muscles slipping freely
Beneath the fine skin,
The small joints miracles of perfection.
In confident awareness,
In the pride of being alive,
It lifts with grace the pointed white hooves.
Between the foal and its mother is a great love.
It moves with her almost as one,
Yet in no way bound,
While every upright shining hair
On its short ruffle of a mane,
Dances with joy.

MARY KENNEDY

The foal nuzzling its mother,
velvet fumbling for her milk.

FERENC JUHÁSZ, b.1928,
FROM *"BIRTH OF THE FOAL"*

WAR GOD'S HORSE SONG

My horse with a mane made of short
 rainbows.
My horse with ears made of round corn.
My horse with eyes made of big stars.
My horse with a head made of mixed waters.
My horse with teeth made of white shell.
The long rainbow is in his mouth for a bridle
 and with it I guide him.
When my horse neighs, different-coloured
 horses follow....

Before me peaceful
Behind me peaceful
Under me peaceful
Over me peaceful –
Peaceful voice when he neighs.
I am everlasting and peaceful
I stand for my horse.

LOUIS WATCHMAN, TRANSLATED FROM THE NAVAJO

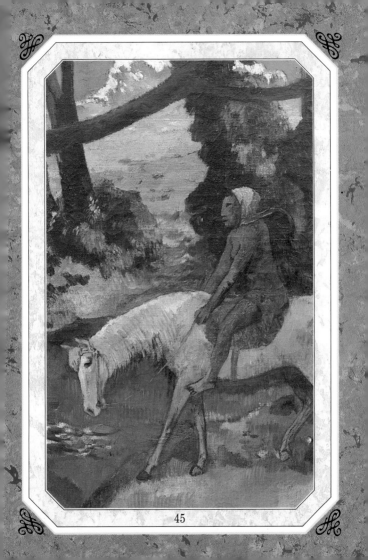

A horse turned out in a field is very different from a horse that is being led or ridden. Take him out on a cold day – there's hardly time to slip off the halter or unsnap the rope before he's off. He gallops, stops, spins round, stares, arches his neck to shake his head and gallop off again.

How beautifully supple and balanced he is! He can gallop from a standstill, stop dead, flick round a tight turn, slip, recover gracefully, swerve, change legs three times in three strides, this horse who has never managed a flying change with you. It is sobering to watch from the gate and realize how a rider limits him. Even a good rider. A meat-fisted sack of potatoes bouncing about throws him off balance completely....

He charges down from the top corner and stops with four feet together, head high, snorting, tail up like a stallion. One eye is on the gate to make sure he is admired, and he snorts into the wind like a dragon, then trots out, sailing, this horse you can't persuade into more than an apology for an extended trot.

MONICA DICKENS, FROM *"TALKING OF HORSES..."*

The eternal and wonderful sight of horses at liberty is magical to watch. One could spend hours looking at horses that have been turned out into a field: playing games, galloping from one end of the field to the other, occasionally squabbling or rolling luxuriously.

BERTRAND LECLAIR, FROM *"1001 IMAGES OF HORSES"*

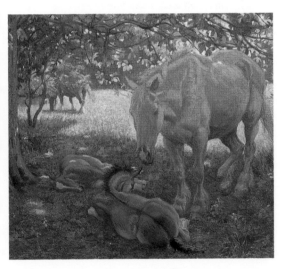

Let the dark mountain shake to the thunder
 Where the wild horses trample the fern,
Let the deep vales re-echo and wonder,
 When, like an eddy, they circle and turn!
Watch the lithe motion
Run free as an ocean,

Mark, in their starting, the pride of their bearing.
 Swift wheel the leaders, each in his place;
Snorting, they stare at us, timid and daring,
 Ere with a whirl they are off at a race.
O, the wild sally,
As, down through the valley,
Turn they again to the mountains they know;

DAME MARY GILMORE, FROM *"THE WILD HORSES"*

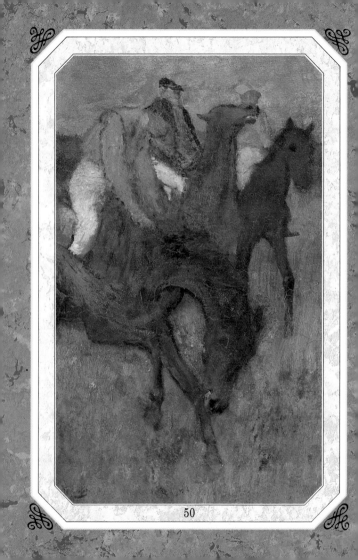

TEAMWORK

The spirit of that first man who had the vision
to see why a horse was shaped like that, and the
nerve to jump on its back and twist his fingers
in its mane is still with us now, here where
the horses are, sharing this strange,
compelling partnership, working, or riding, or
watching them over the gate of a field, chewing
a blade of grass.

MONICA DICKENS (1915-1922)

A good horse knows just when to turn a cow,
just how to cut a steer from the bunch. A good
cow pony knows, as if by instinct, when to walk
slowly through the brush, how to miss the
gopher hole at a high canter. Many a cowboy
owes his very life to his horse. The cowpoke and
the cow pony become not just a team working in
unison, they become as one.

ROYAL B. HASSRICK

CRAZY!

All horses sometimes like to put on an act. They sham lame at the start of a ride. They snort in terror at a white stone going away from home, but don't give it a glance on the way back. They clench their teeth and refuse to take the bit. They swing their head up high if you are a short person with a bridle, but if you are tall with long arms, they don't bother. They won't let you pick up a foot. If you have a back foot in your lap to clean it, they rest their weight on you, as if they couldn't stand a moment longer on three legs.

MONICA DICKENS (1915-1922),
FROM *"TALKING OF HORSES..."*

Be wary of the horse with a sense of humour.

PAM BROWN. b.1928

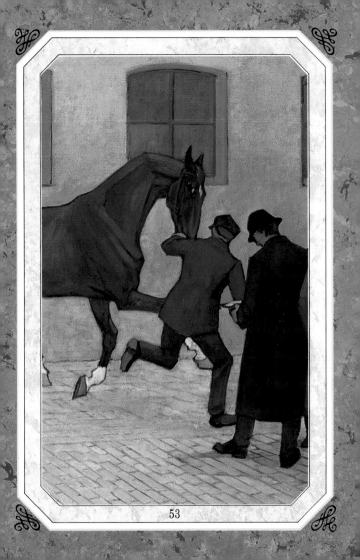

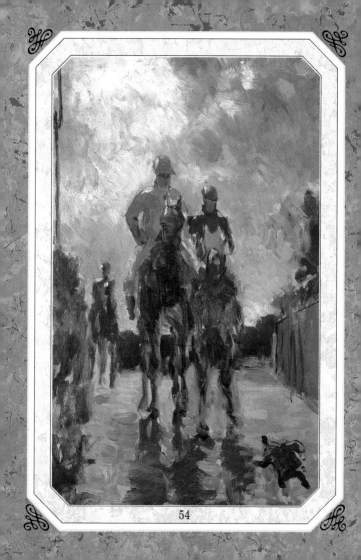

The best thing for the inside of a man is the outside of a horse.

LORD PALMERSTON (1784-1865)

≈

Men are better when riding, more just and more understanding, and more alert and more at ease and more under-taking, and better knowing of all countries and all passages; in short and long all good customs and manners cometh thereof, and the health of man and of his soul.

**EDWARD PLANTAGENET,
SECOND DUKE OF YORK (1373-1415)**

≈

I say to parents, especially wealthy parents, "Don't give your son money. As far as you can afford it, give him horses." No one ever came to grief – except honourable grief – through riding horses. No hour of life is lost that is spent in the saddle.

**SIR WINSTON CHURCHILL (1874-1965),
FROM *"MY EARLY LIFE"***

≈

Hours and hours of the freedom of riding – it's a lifetime remembered with pleasure.

MINDY H. THOMSON

Take the life of cities!
Here's the life for me.
'T were a thousand pities
Not to gallop free.
So we'll ride together,
Comrade, you and I,
Careless of the weather,
Letting care go by.

ANONYMOUS

If a car passes me when I'm on a horse, I always think: if I were in that car and saw me, I would wish I was me. Wistful children's faces, staring out of the back window, agree.

MONICA DICKENS (1915-1992)

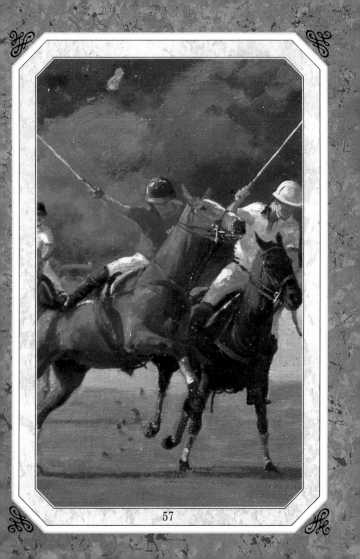

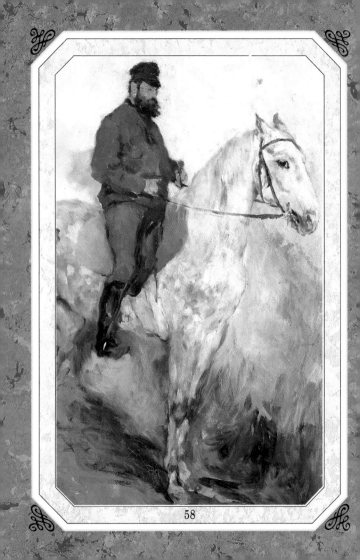

... in whatever way our recollections may be dimmed by the passing of time or by our acquaintance with new objects and interests, the memory of a horse's head, when it has been loved in life, will never, somehow, be erased. Other horses may prick their ears at our approach, but not, perhaps, in quite the same way as those were pricked; other horses may lift their heads in a whinny, and yet with a different lift; another horse may have a small white patch in the centre of its head, and yet not of that essentially individual pattern that we loved so well; other horses may nuzzle up to us, and yet not with the same, well-remembered caprice or affection. That head, whether or not we possess its recorded image in our most treasured album of photographs, will be a picture whose endearing characteristics will stay with us, not merely while the joy of the saddle is ours, but as long as we have memory of green fields and hedges, and the music which comes from the clump of horses' hoofs.

FRANK CREW, FROM *"DEVOTED TO HORSES"*

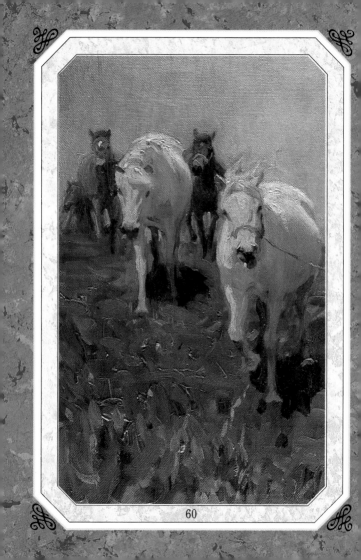

ADDICTS FOREVER

God forbid that I should go to any heaven where there are no horses.

R. B. CUNNINGHAM-GRAHAM

Machinery may make for efficiency and a standardization of life, but horse love is a bond of freemasonry which unites the entire race....

WILLIAM FAWCETT

When I can't ride any more, I shall still keep horses as long as I can hobble about with a bucket and a wheelbarrow. When I can't hobble, I shall roll my wheelchair out to the fence of the field where my horses graze, and watch them.

MONICA DICKENS (1915-1992),
FROM *"TALKING OF HORSES..."*